PARIS GRAFFITI

PARIS GRAFFITI

Photographs by Joerg Huber

Text by Jean-Christophe Bailly

Thames and Hudson

Translated from the French by Charles L. Clark.

© 1986 Fernand Hazan, Paris.

First published in the USA in 1986 by Thames and Hudson
Inc., 500 Fifth Avenue, New York, New York 10110

Library of Congress Catalog Card number 86-50198

Printed and bound in Spain

TRACES

Painted with a brush or a spray gun (or rather, a can of spray paint), drawn in chalk or with a felt pen, or carved onto stone or plaster with a makeshift tool, graffiti are as old as memory itself. From birth, we are surrounded by walls that have not been left bare, walls that anonymous hands have covered with hurried inscriptions or demands, sometimes with drawings or caricatures. A sort of wild counterpoint to the regulated distribution of images and signs, graffiti are so familiar to us that, in our travels, we are surprised whenever we are not confronted with them : for there are countries with graffiti, and countries without. In addition to this spatial pattern, there is also a temporal stratification, which may be treated in terms of *styles*. Joerg Huber's book of photographs gathers the most vivid examples of the latest style to be seen on the walls of Paris, which differs from the carved style Brassaï photographed some years back as well as from recent New York scribble styles and the international tradition of the slogan in all of its metamorphoses.

Stencilled graffiti differ from all other graffiti in at least two ways. First, they can, by definition, be reproduced (in theory, infinitely, even if their actual occurrence

tends to remain fairly limited); second, their intentionally iconic character turns them into authentic *images* of urban culture. The essence of these *graffiti* lies in a break : close to creation, they are, at the same time, separated from it by the very fact that they can be reproduced. Reproducibility can, of course, be considered a kind of creation, especially since the series constitutes one of the credos of modernity. Yet, it must also be recognized that the imitation of the world of production is inherently limited in the case at hand by the fact that the interest of a stencilled image, reproduced on a city's walls, is linked to the surprise it provokes. In other words, the series does not really appear as a series (as it would, for instance, if it were exhibited in an art gallery or museum) although each isolated image is determined by the fact that it is part of a series. It might be said that the series is not stocked, but rather dispersed throughout the city like a mark or signature. Consequently, the particular serial effect which characterizes this pictorial genre is turned into a game of hunting down the images in the series. Signs are repeated at different points of town; this repetition, tracing out a circuit, triggers the perception of a network :

various series form a narrative network, and each image is at once a fragment and an echo of it. The "hot spot" for such networking is linked to Paris nightlife in the eighties: the Right Bank between the Bastille and Les Halles, with little islands scattered throughout the rest of town.

The following pages present – on the quiet, as it were – the song of the network. Joerg Huber's book, with its precise framings of frail and fleeting images, is, above all, to be looked at and preserved as a portrait of Paris today, as the trace of a world of traces. This portrait is marked by today's dominant imagery, the comics, yet distinguishes itself from that imagery or gracefully plays with it. It is a bit as if a group of interlopers had been recorded for posterity in pictures of their tattoos: the city of Paris has been tattooed in a way which vacillates between the chic and the cheeky, between the surprises and redundancy which characterize the making of its nights. And yet, these night images are visible in broad daylight; and, they possess, when their beauty sets them apart, when their significance comes through, something of the lightness, of the whirling evanescence, of early morning: a trigger to thought as one leaves a café, the twinkle of an image which catches the

eye for its charm or for no reason at all, the gay truth of a world without causes where caprice, exhausted yet refreshing, is all that remains.

Modest or ironic markers and not haughty signatures, these graffiti are meant to be ephemeral, to be affixed in their ephemerality. The silhouette of Fantômas, or that of an Utamaro woman, a caravanserai of multicolored camels, a parrot on the Eiffel Tower, Tintin, an ocean liner, an Egyptian eye, a snake, the devil, dancers, saxophone players – what are these images, clothing our walls, really after ? Where are they pointing ? Doubtless, they are not after anything and are saying nothing but a cheerful "I'm here" which associates their ephemeral existence with the migratory character of their appearance. And this unimposing "I'm here" seems to imply a considerate "are you coming ?" addressed to nobody in particular. For, despite the inevitable influence of imported trends and codes, these images are not appeals to anyone or for anything; they designate no one group and in no way resemble the proclamations which flourished in and after 1968. No individual or group, no "avant-garde", is behind these inscriptions. Certain graffiti-makers with fairly classical aims may wind

up on the art scene, wavering between perturbation and recognition. It doesn't really matter if they do, but something will have been lost along the way. Seized in flight, before it's too late, as the recently-launched fashion they are – and thus as the mode (of inscription, expression, and writing) they are – there is something about stencilled graffiti that is hard to grasp because it is as evanescent as the times. These graffiti are traces of the times exhibited, or rather abandoned, on our walls, a way of making us see the walls around us : offering images a free place to stay, our walls – with their roughness and their smoothness, their confrontations of textures, and the confused murmur of memory they emit – have come to resemble fragments in a huge aleatory iconic field.

Were this but the latest variation in the surface of such a field, or the most recently observed state of the palimpsest formed by a city's walls (speaking in its voice), the fact would remain that this variation, or state, speaks of the times in the language of the times : using little, coloured characters which are like the traces of a familiar, yet unknown, tribe of hunters. It is, of course, the tribe of ourselves which is thus rendered – as validly perpetuated

and portrayed in the light playfulness of these signs as in the pomp of golden letters. Could it be that these images are a magic powder being sprinkled in our eyes? In any case, they are like a powder around the eyes, a joyous lesson in the art of make-up on the city's walls.

The staircase descends and turns. A geisha has been painted on the opposite wall. We have been modern for so long in a world which is already so very old. There is a gigue of signs telling us this, innocently, in new colours.

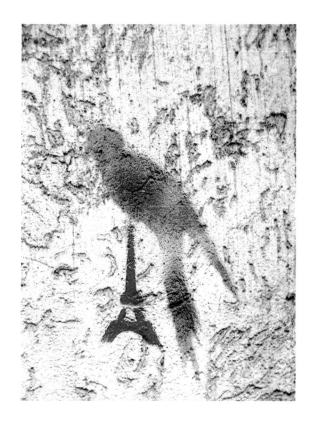

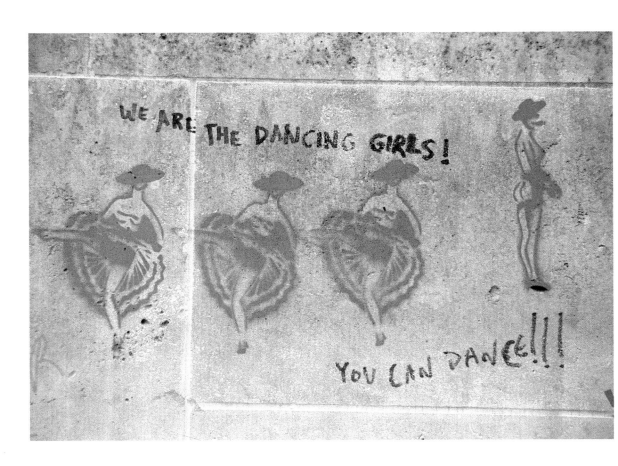

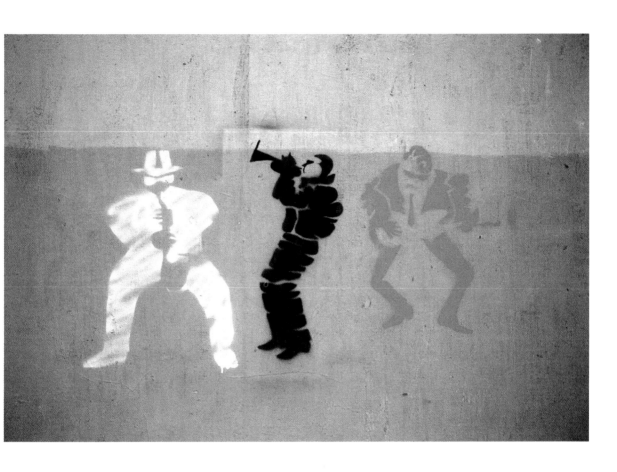

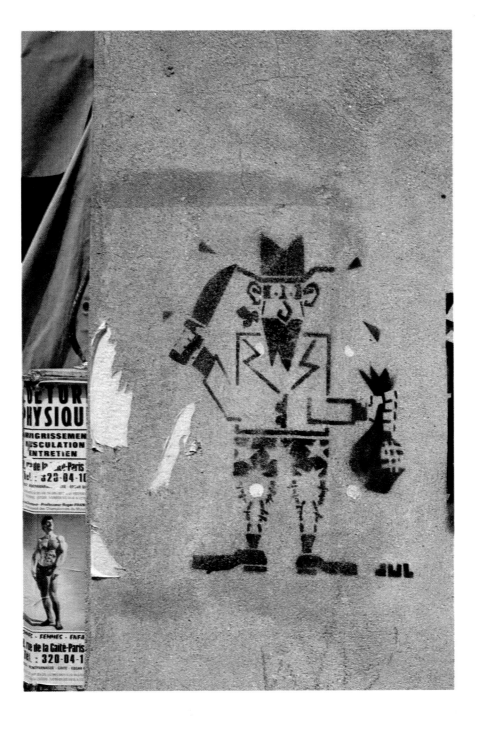

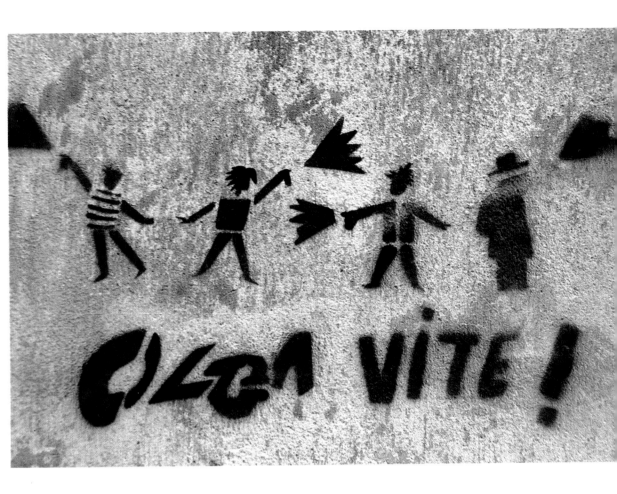

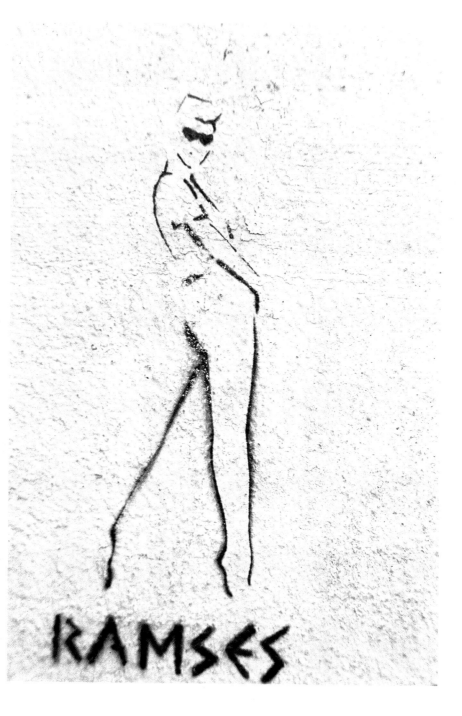

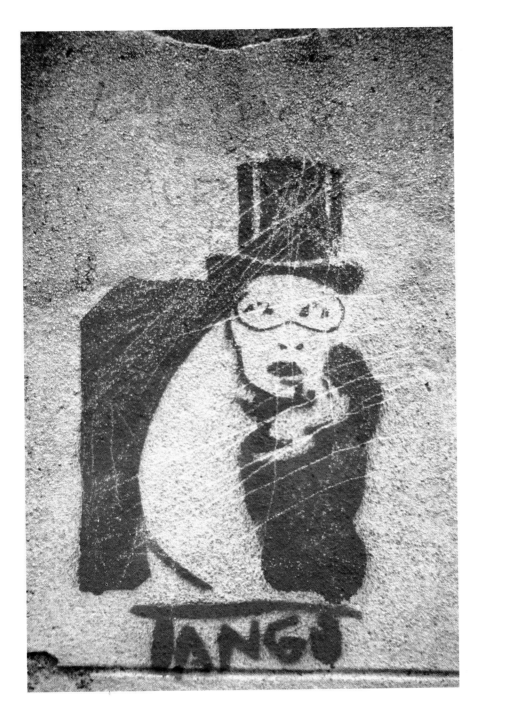

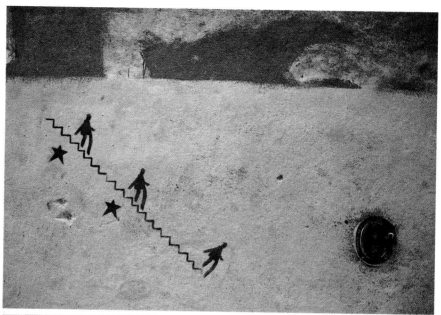

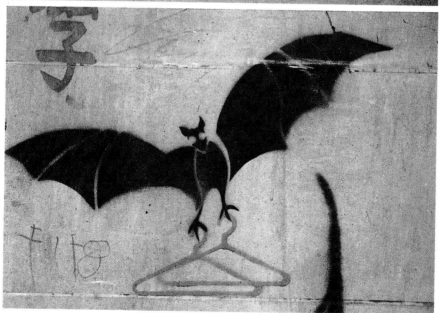

20

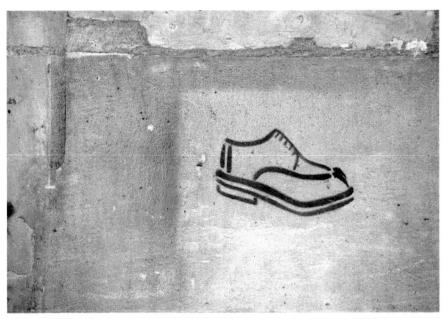

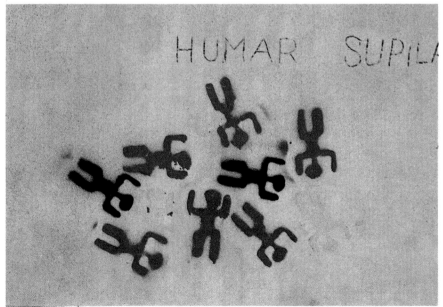

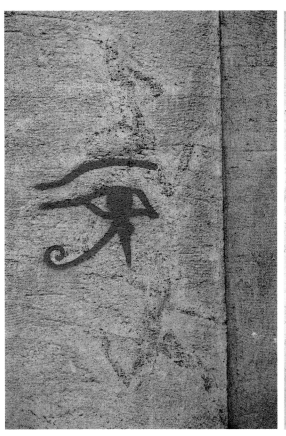

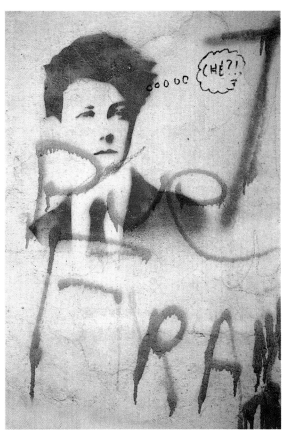

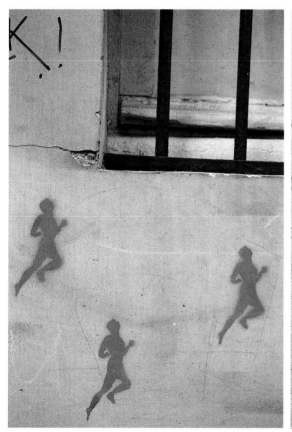

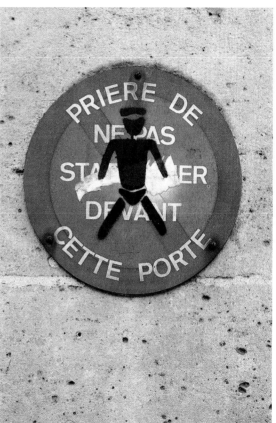

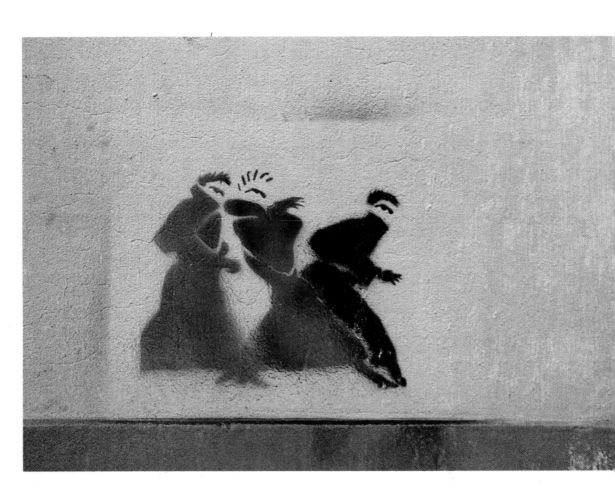

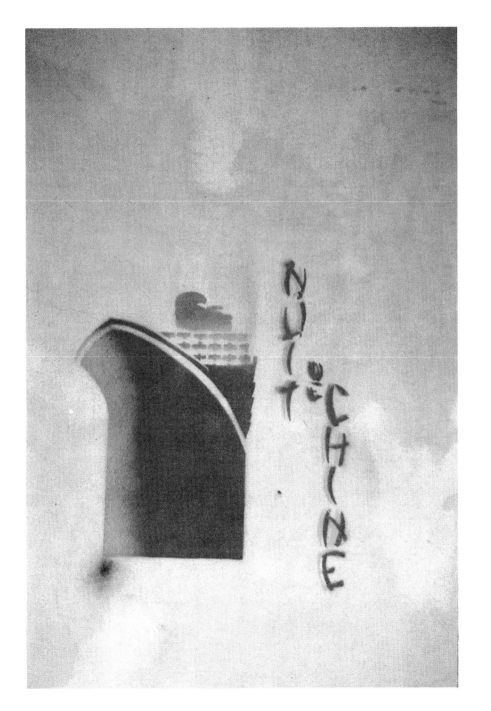

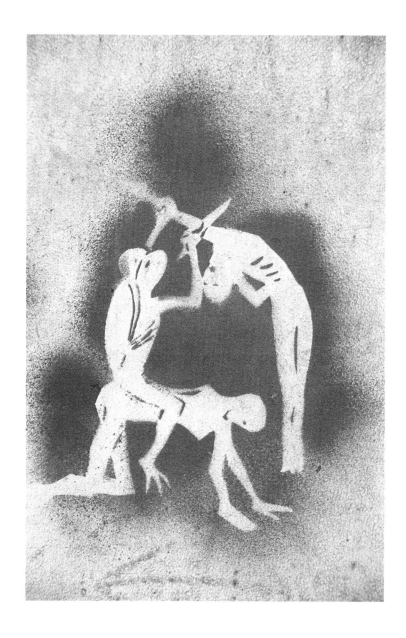

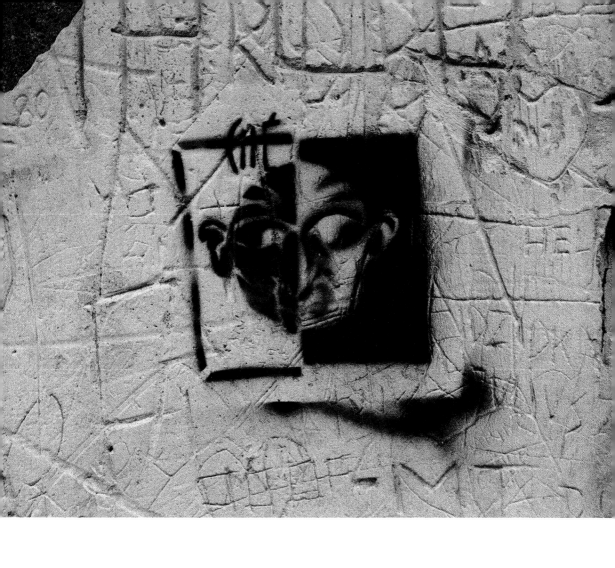

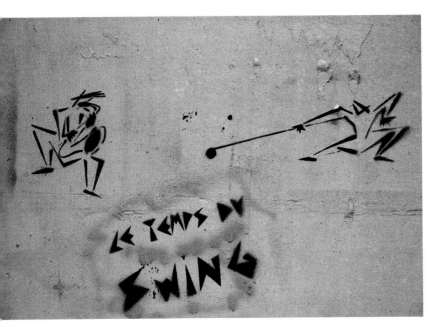

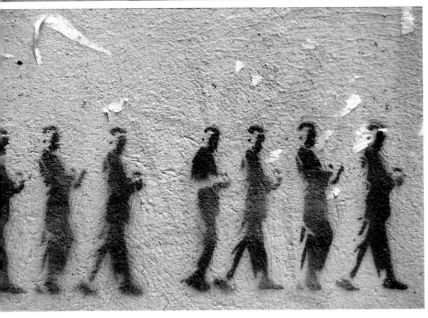

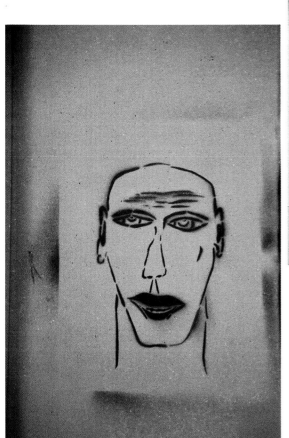

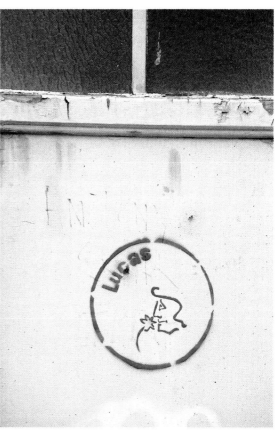

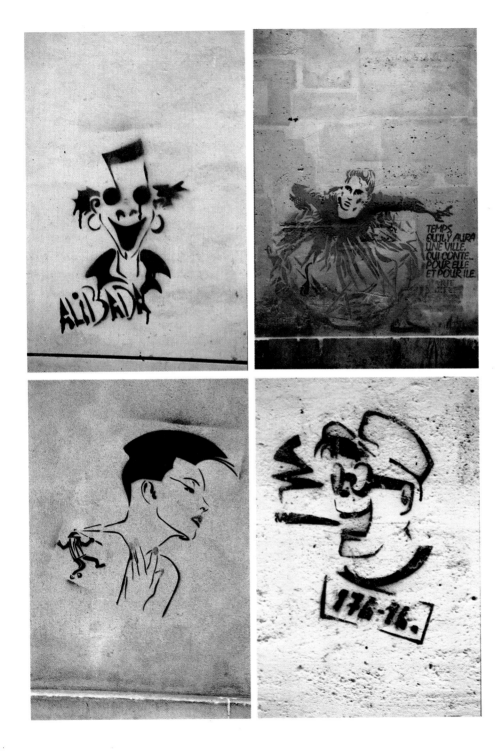

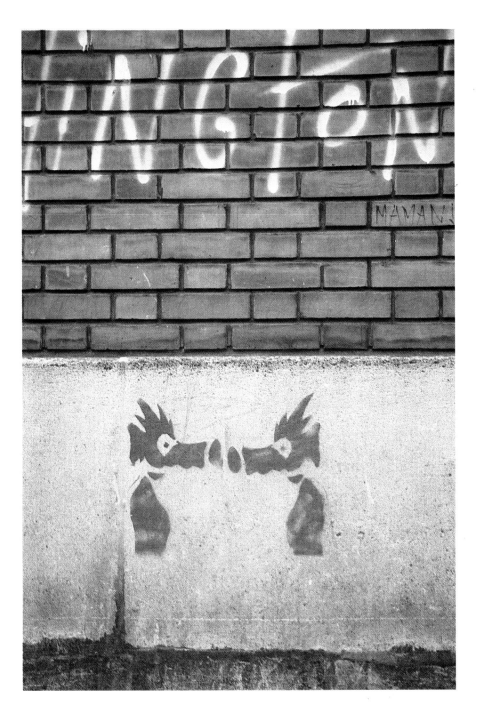

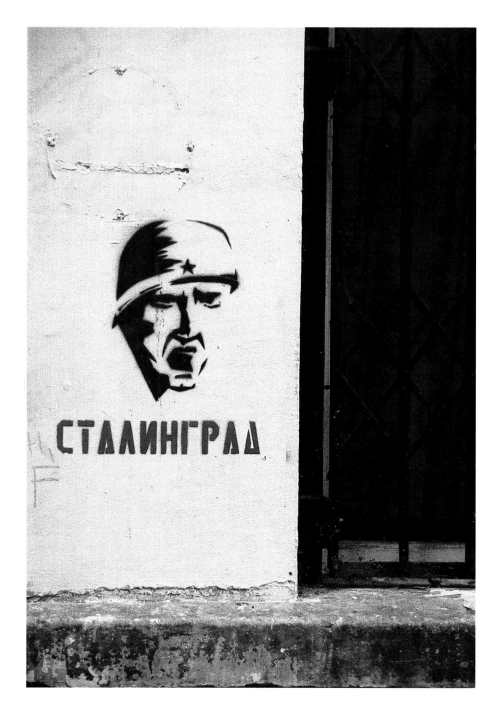

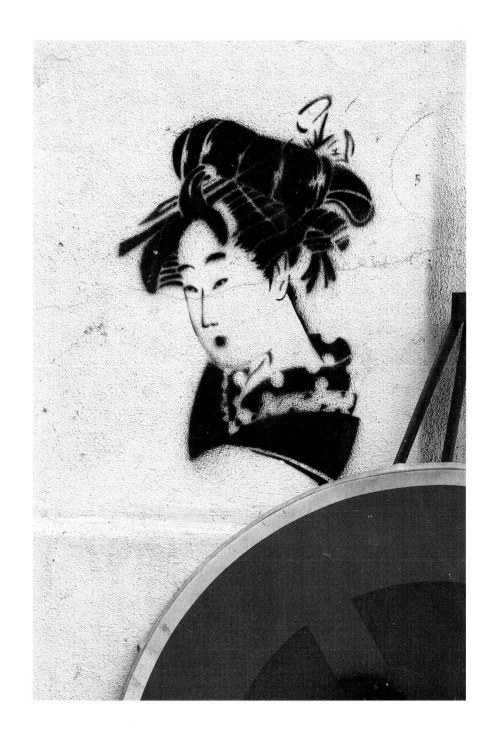

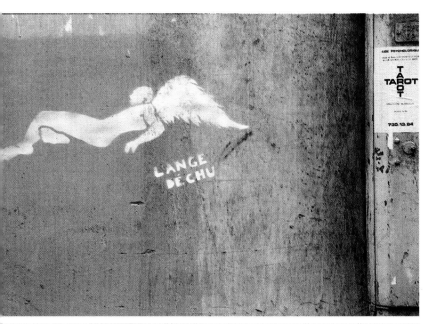

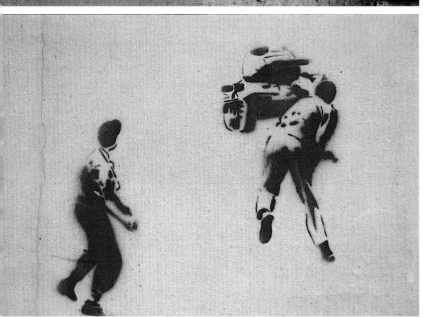

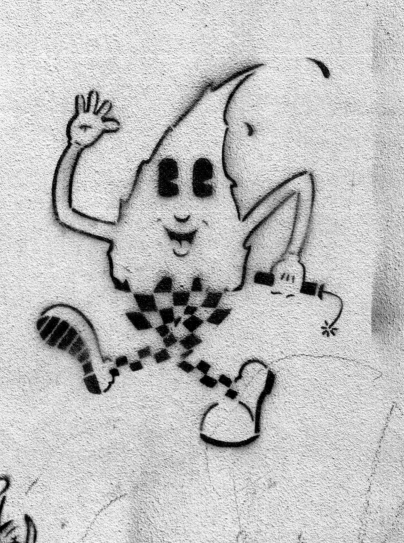

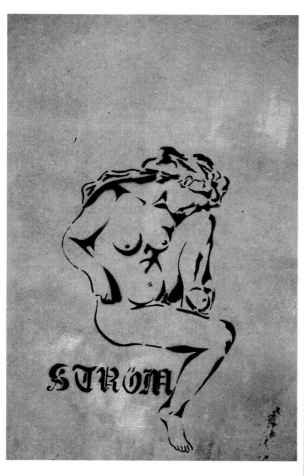

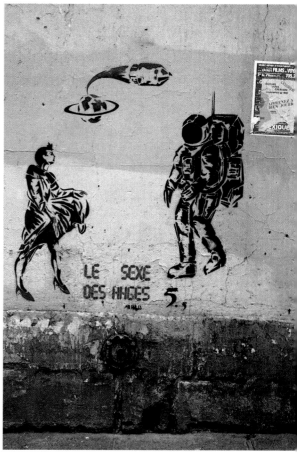

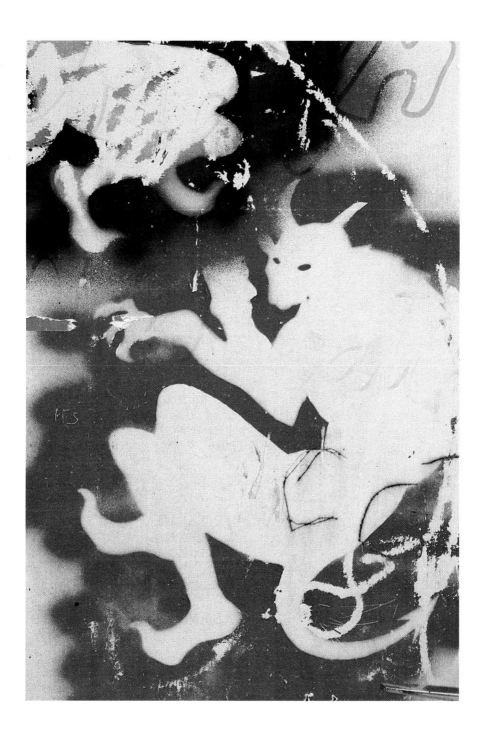

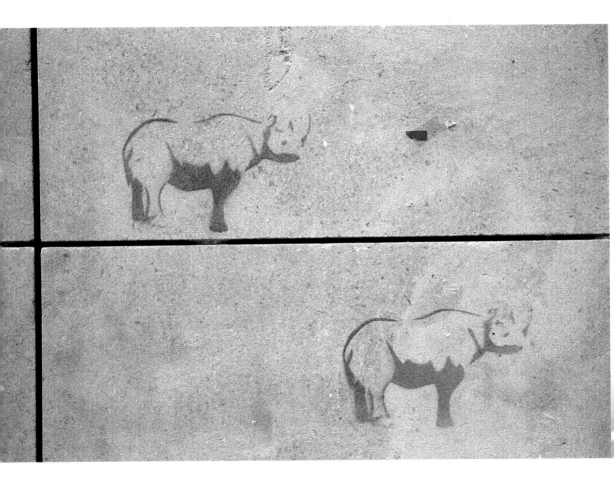

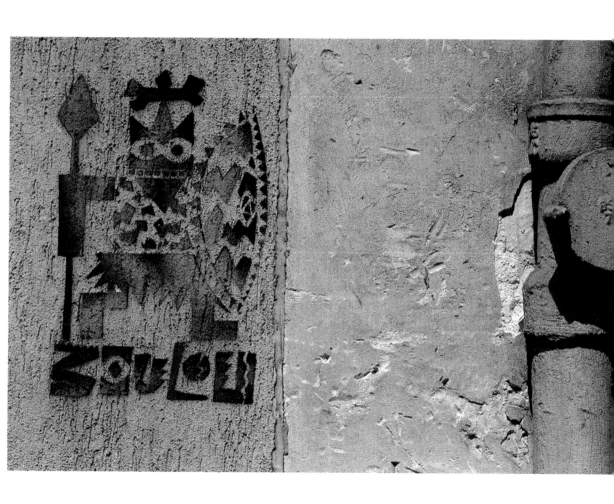

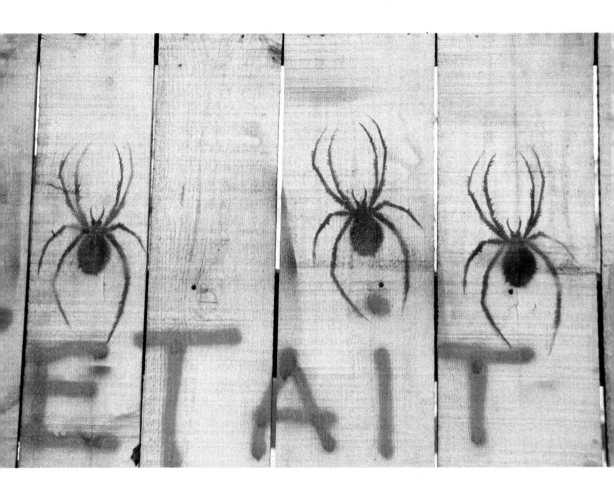

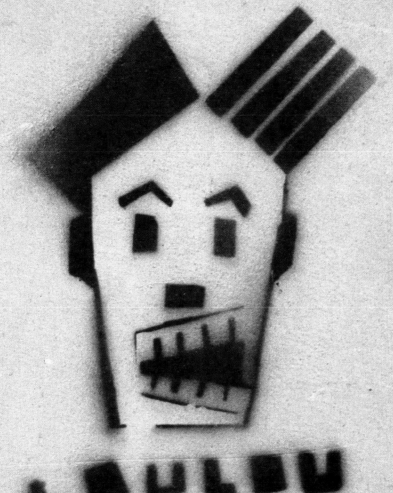

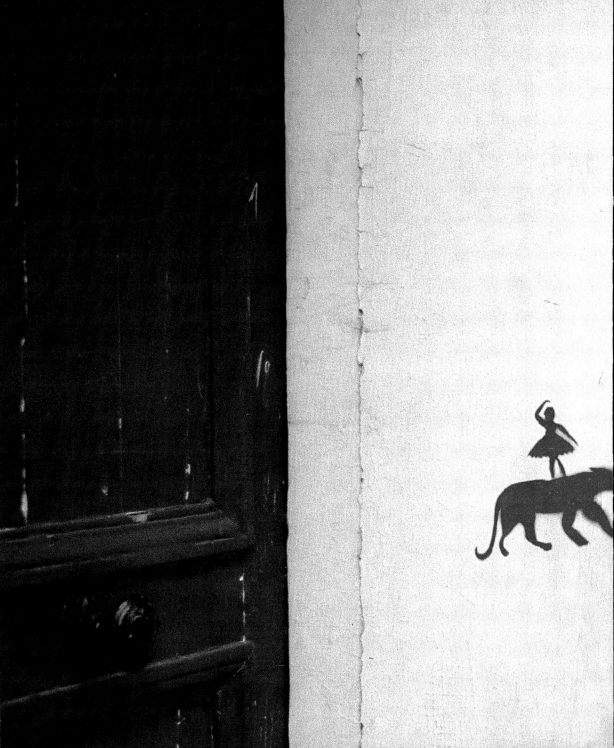

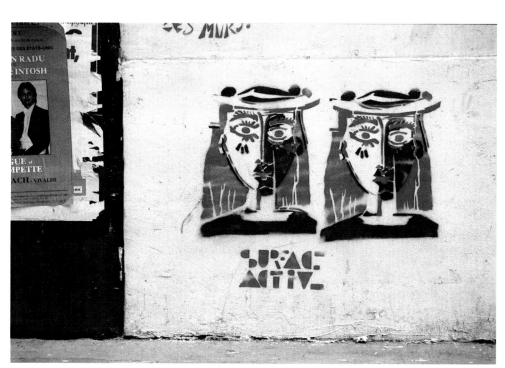

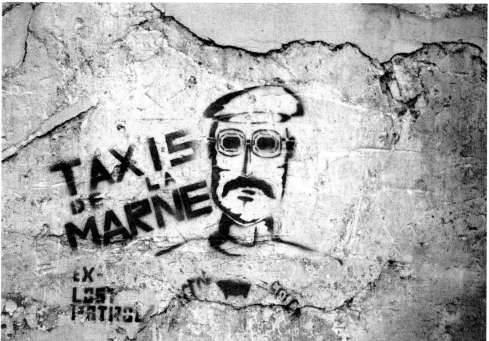

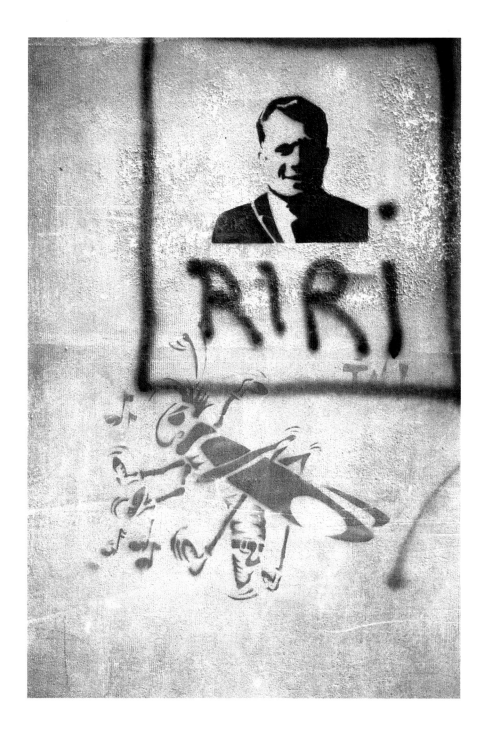

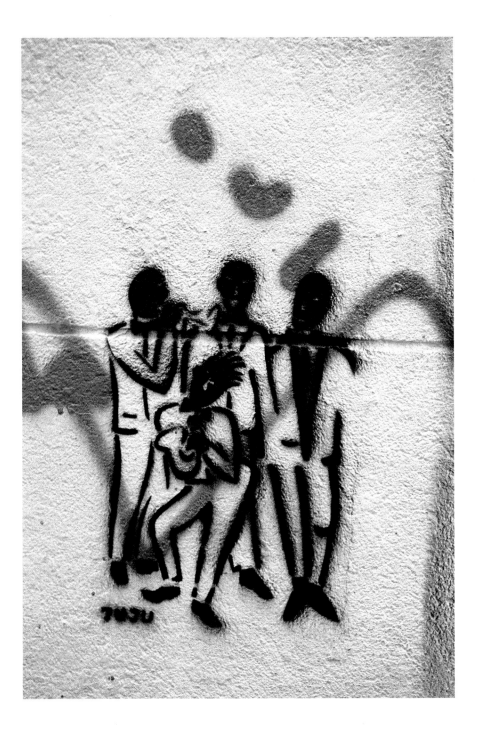

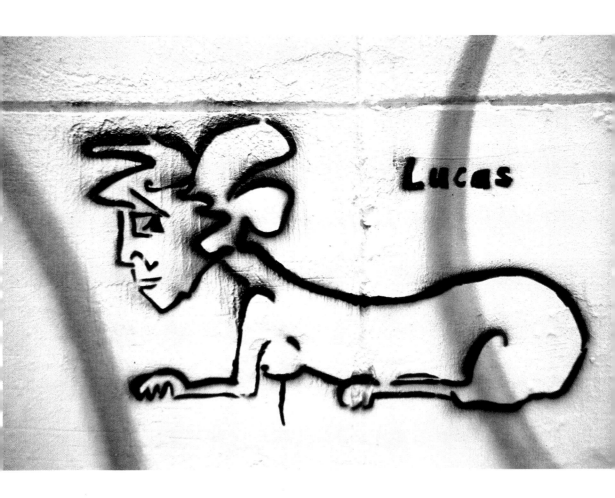

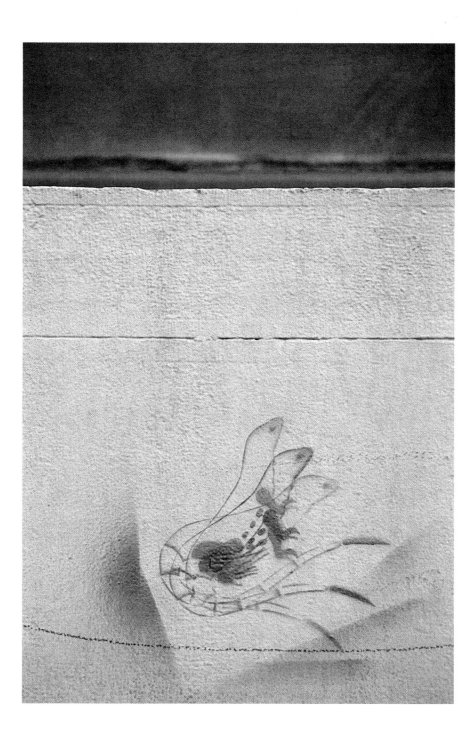

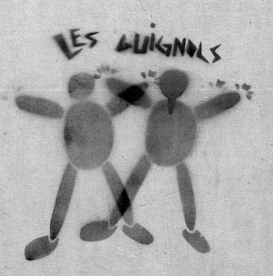

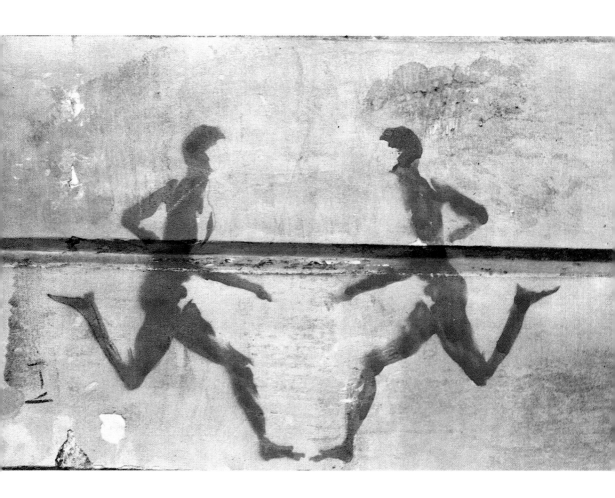

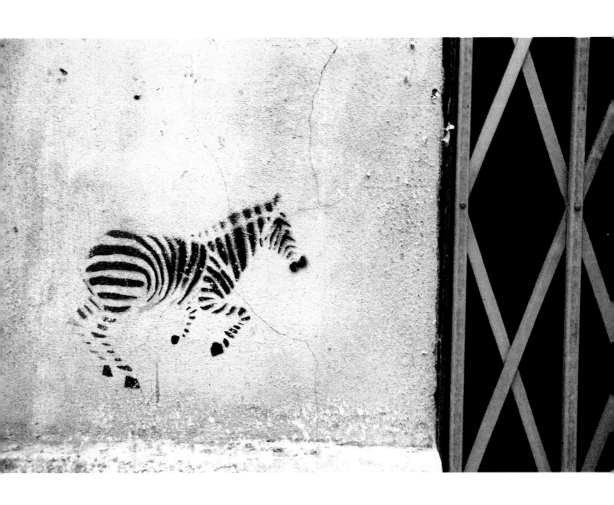

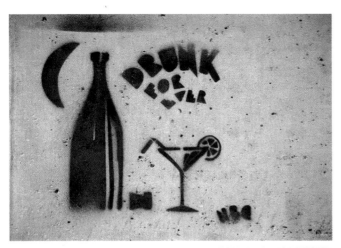

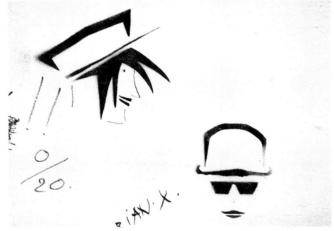

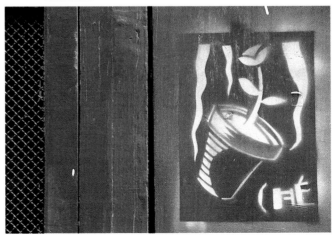

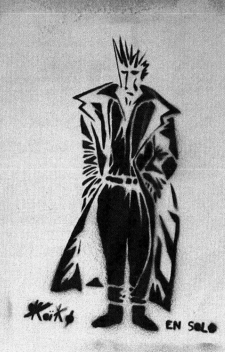

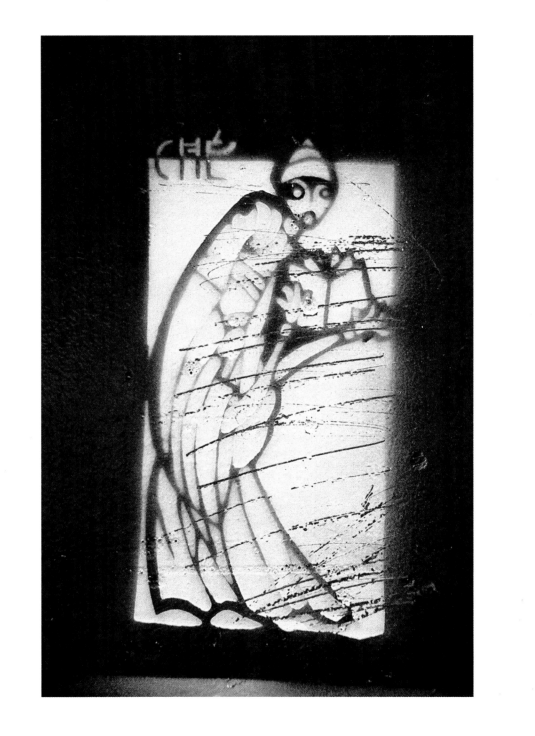

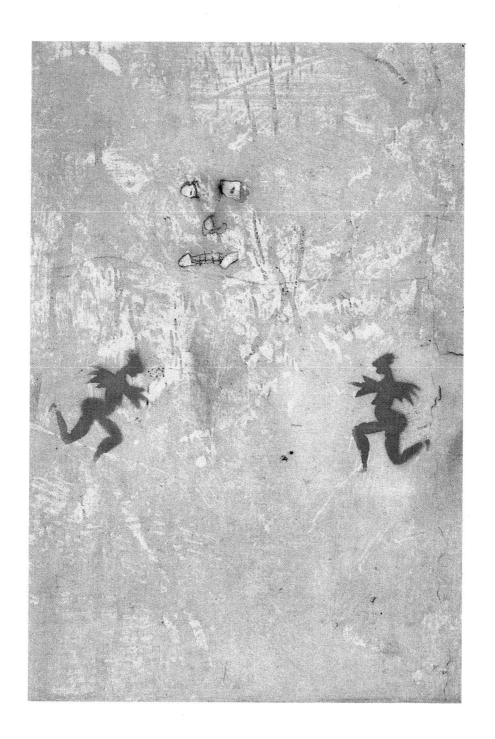

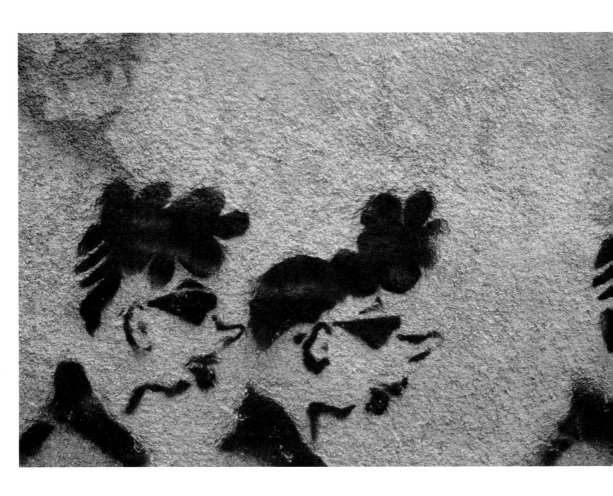

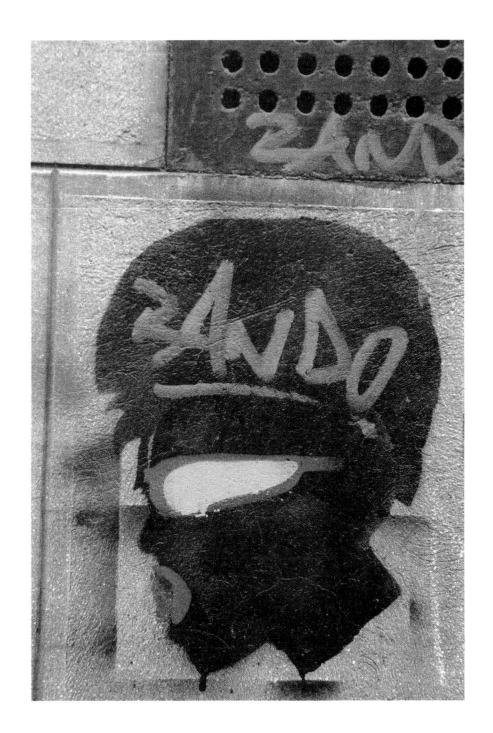

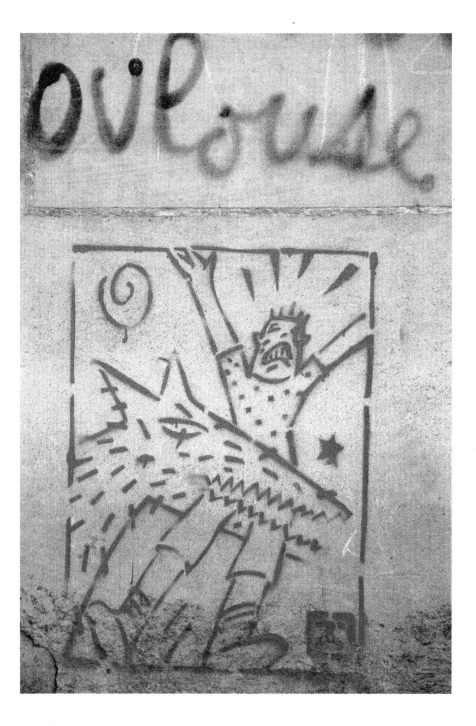

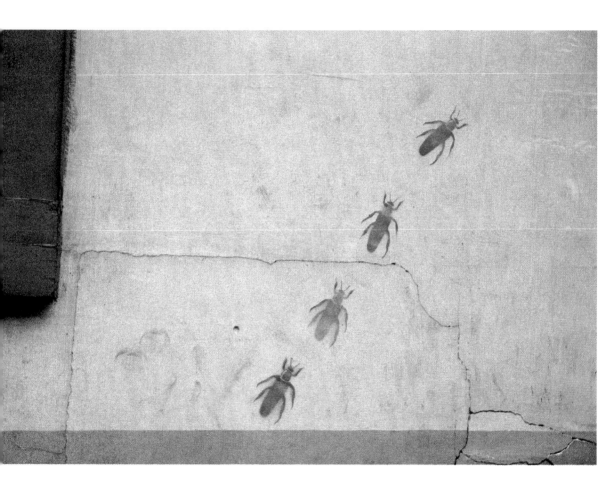

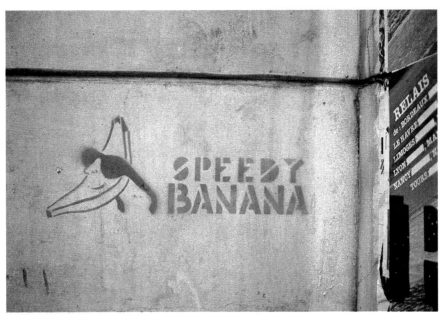

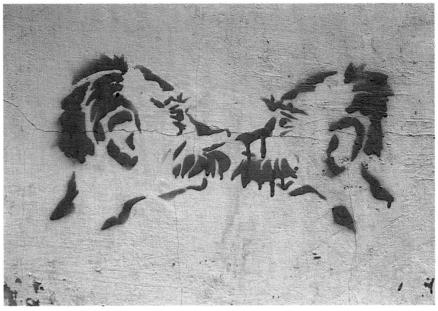

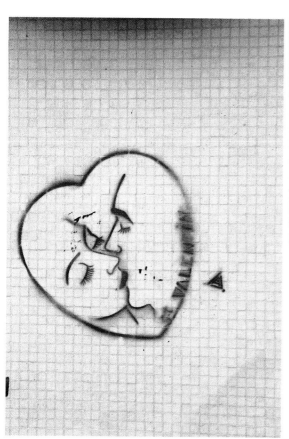

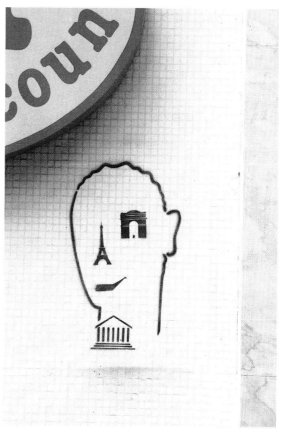

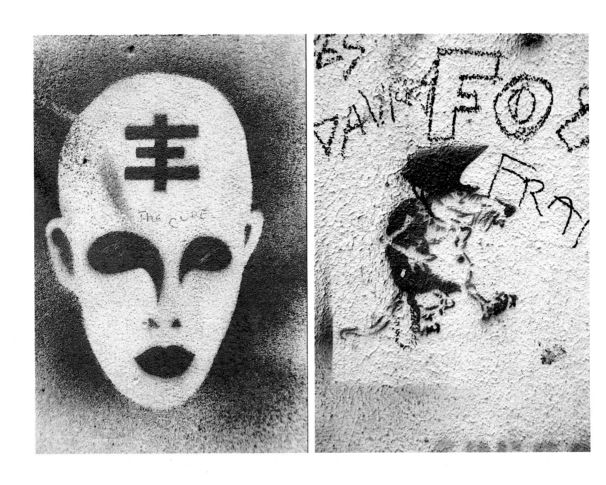

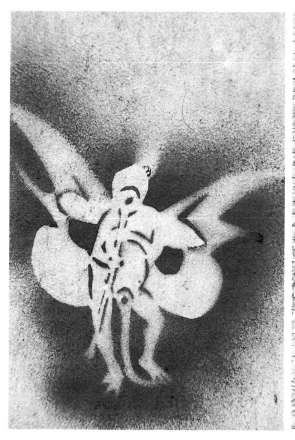

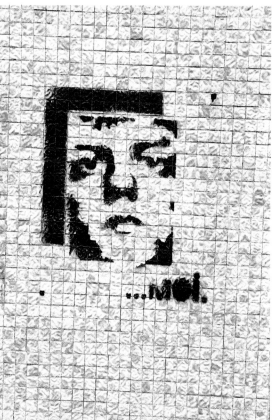

...MOI.

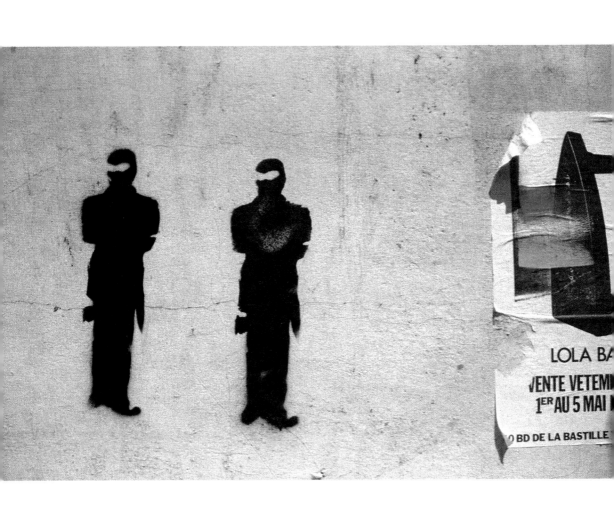

LOLA BA

VENTE VETEM

1ER AU 5 MAI

0 BD DE LA BASTILLE

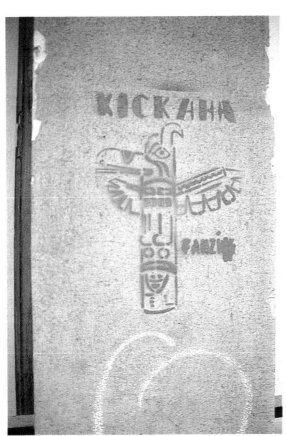

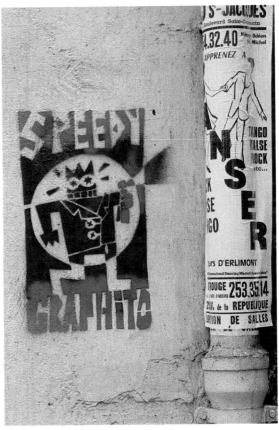

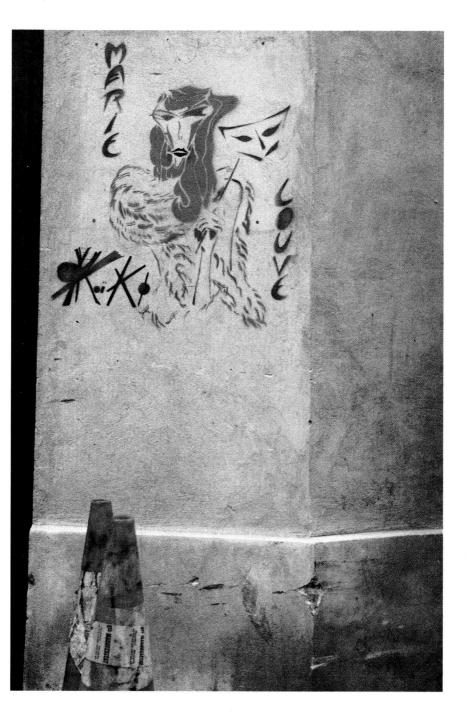

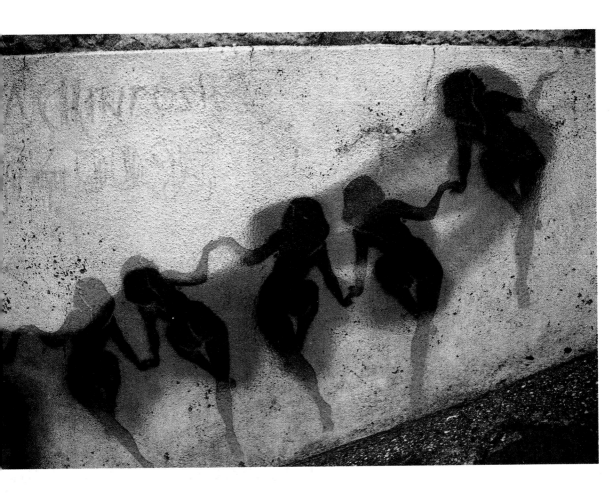

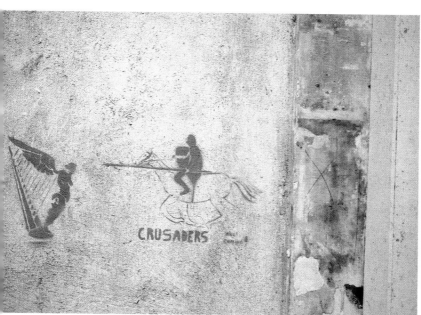

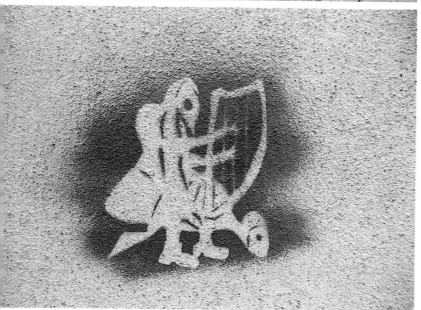

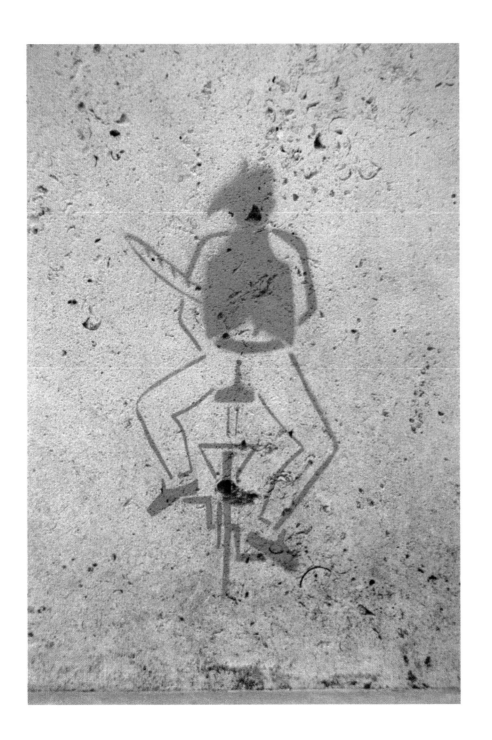

Joerg Huber

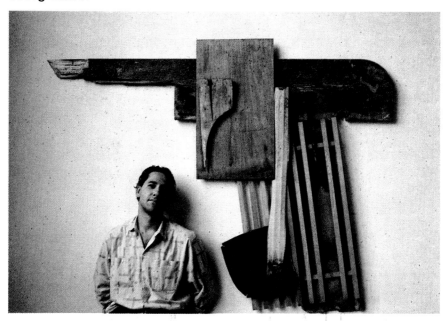

Born in Landshut (Bavaria) in 1953.
Moved to Paris in 1978
where he continues his work
in plastic arts.
In 1984 his first book "L'île Barricadée"
was published, showing images
of the Art of Danger.